THE *Adventures* OF LUCAS CLAY

ROD SHAHAN

outskirts press

The Adventures of Lucas Clay
All Rights Reserved.
Copyright © 2017 Rod Shahan
v1.0

The opinions expressed in this manuscript are solely the opinions of the author and do not represent the opinions or thoughts of the publisher. The author has represented and warranted full ownership and/or legal right to publish all the materials in this book.

This book may not be reproduced, transmitted, or stored in whole or in part by any means, including graphic, electronic, or mechanical without the express written consent of the publisher except in the case of brief quotations embodied in critical articles and reviews.

Outskirts Press, Inc.
http://www.outskirtspress.com

ISBN: 978-1-4787-8366-4

Cover Photo © 2017 Rod Shahan. All rights reserved - used with permission.

Outskirts Press and the "OP" logo are trademarks belonging to Outskirts Press, Inc.

PRINTED IN THE UNITED STATES OF AMERICA

*Dedicated in loving memory to my daughter
Jessi*

Table of Contents

1. What a Night .. 1
 Up a Creek ... 1

2. Riding In The Clouds ... 5
 Wild Horses .. 5

3. Miss Vicky's Pies ... 11
 No trouble at all ... 11

4. Moon Over Spirit Valley ... 20
 Feathers of Faith .. 20

5. Heavens Cowboy .. 31
 Angels in the Saddle .. 31

Introduction

A man will search most of his life for something that has always been directly in front of him. Life itself as it was given to us and intended to be lived. Some will see this early on and then some will always stay blind to it. But for most, we merely need to open our eyes, be happy and imagine.

And so are the times of Lucas Clay, a simple cowboy living life with his eyes wide open.

CHAPTER **1**

What a Night

Up a Creek

YA KNOW IT hasn't been that many days since ole Ruger and I rode up to the Green Basin trail head to make sure those pesky beavers weren't stopping our water supply again. But for some reason that ole horse has been acting like,, well lets just say that a dog is not mans best friend, its your horse, and mine is a 17 hand bay gelding I call Ruger, named after my favorite six shooter. His nose will out sniff the best blood hound, eyes will perform like an eagle, and out run the healthiest deer. Well this ole horse finally came running up to the house just a yelling and standing on those hind legs like he was reaching for the stars, then ran back to the creek and stomped in the water like a bear catching salmon. I grabbed my hat and coat and ran down to him thinking there could be a mountain lion somewhere near and thats what all the fuss is about. I was trying look and listen for a big cat, but I also noticed none of the other livestock were nervous down by the other barn, they were as calm as could be.

There hasnt been any lions around here in quite a long

time since myself and some of the neigbors went after two of them that were killing some of our calves. I know it wasnt them cause they are both rugs now.

Ruger is still insisting that something is wrong on up the creek and if I dont get my gear and go look he will keep this up all night. It pretty cold out tonight but there is a full moon with plenty of light reflecting off the snow.

I got a few extra pieces of gear from the cabin, saddled Ruger and started up the bank of the creek. I could tell through the snow covering the creek that there was plenty of water coming down, so surly it wasn't those beaver again. But by golly Ruger was sure in a hurry to get up on the mountain, and at this point I just couldn't figure out why. Now I do respect the instincts of my horse, but he also respects my decision to slow down, for petes sakes, its the middle of the night and we are deep in the woods. I knew that what ever was lying ahead, between the two of us we can handle it. We started a nice slow walk looking from side to side taking in every noise and movement in the forest. The bright light of the moon was shining through those Ponderosa pine casting hundreds of shadows on the snow which almost seemed to be lit up from underneath.

I guess taking in all this twilight beauty I wasn't taking in what Ruger was trying to tell me. He was bobbing his head up and down then reaching back to nudge me on the leg. We stopped for a moment and stood in silence. By golly I could swear a heard a baby in the distance or at least what sounded like one. We picked up our pace a little dodging all the small scrub oak and jumping over the laid down dead trees, and the sound got louder and louder.

I jumped down off of Ruger and walked closer to the creek looking up and down trying to pin point the sound. Next thing

WHAT A NIGHT

I knew Ruger had walked up behind me and shoved me into the water towards the surprise of the evening. Strait in front of my face were these big pitiful eyes of a freezing calf. I recognized this little guy as one of Miss Hunters, she was the only one on this side of the mountain with prize Herefords and this little one somehow wandered off. His left rear leg was stuck in the fork of a branch which was more than likely part of the old beaver dam. I climbed back up the bank to Ruger , took one end of my rope and wrapped it around the saddle horn and the other end around me. I went back into the creek and told Ruger to keep it tight. I took the calves leg out of the branch then gave him a big bear hug and told Ruger to get us out of here. He backed up and pulled the two of us from the creek onto the snowy bank.

 Now I may be getting older, but not so much that I can't throw a calf over my saddle and sit in behind him. Both the calf and myself were cold as ice after struggling in the water and winter time to boot. We are only about a mile from the cabin so between Ruger, the calf and myself I know we can have enough body heat to make it that far.

 I swear one of the longest rides a man can take is in the middle of the night, your cold and wet, waiting to see the cabin around the next bend and the glimer of a lantern I left hanging on the porch. Then finally, there it is, and you know that warmth is not far away.

 Once back at the barn I let the calf out in the pen, I figured I would take him over to Miss Hunters later today and tell her about how we came across him. I unsaddled Ruger, brushed him down then headed back to the cabin. I had to stop along the way and sat on this large rock looking back towards the barn. Ruger was walking behind this calf pushing him around the pen as if trying to keep him warm.

THE ADVENTURES OF LUCAS CLAY

As I sat there watching Ruger and the calf move around the pen and as cold I was, just the feeling of relief that all turned out safe is enough to warm the heart. Now the morning sky was becoming bright redish orange with beams of white shining through the trees. While taking this all in I couldn't help but thank the Lord for the life which he has given me, a life in its purest and most beautiful form. I cant wait to see what is in store for me tomorrow.

CHAPTER **2**

Riding In The Clouds

Wild Horses

HAVE YOU EVER had those nights when it seems you wake up every hour wanting morning to hurry up and get here. You have this feeling that something special is going to happen. You dont know what, but you do know its something good. But then I did choose the life of a cowboy and with that you know that everyday is subject to what God has in store for you. So how could any day be any less than good. But dog gone it, todays feeling had something different.

Finally the slightest hint of daylight was in the eastern sky and I had already made the coffee was heading down towards the barn to see how the night went for my calves on the bottle and of course my horse Ruger. They were just as anxious to see me as I was them. The calves calling for milk and Ruger bobbing his head up and down while prancing in a cirlce around the pen. I got everyone fed and made sure there was plenty of water. I then went back to the cabin for coffee and get my gear ready.

I still had this overwhelming feeling that today had

somethng special in store, even though it was a day of regular chores around the ranch like checking cattle and running fence. What ever it could be I was ready for the adventure or just the good feeling of another great day.

I had so many things on my mind this morning such as what fences needed attention and then how much time I would have left to check on the cattle grazing near Wild Horse Plateau. I pretty much knew that the fence should be ok, cause I just checked it about a month ago, and that there were only seventy head of cattle near the Wild Horse area. So with the feel of confidence towards my days schedule, Ruger and I set out towards the upper ranch with a click in our hoofs and smile on our face. Can it get any better than this.

I'll bet we didnt get any further than a mile from the cabin and all the sudden it dawned on me. Wild Horse Plateau, by golly that was it, the something special I kept feeling. I try to make it up there at least as much as I can because this is also the grazing ground for all the areas wild horses. I like to keep track of the new young ones and which studs are in charge. That and checking on my cattle may be a good reason for going there, but actually, just the site of these magnificent animals grazing on the high mountain pasture and running freely across the country side takes me back to my dreams of riding along beside them as they run towards the days sunset.

Just the thoughts of this stayed on my mind the entire time I was riding the fence lines. We stopped every so often to tighten up some loose wire, and the whole time I kept looking towards the pass in the trees where we would ride toward the trail of the Wild Horse Plateau.

We were getting near the end of the north fence line and so far everything was in good shape and still pretty tight. At the

end of the fence I climbed off my horse and looked down the wire to make sure it was all even and straight. It sure looked fine to me, but so did that opening in the trees where we were going next. I climbed back up on the saddle and told Ruger, "lets head up to the plateau ole buddy" so away we took went at a full run with my hat blowing back on its leather strap and Rugers mane flying in the wind.

This has always been one of my most favorite rides in these mountains. Where the magestic snow capped mountain is lined with the dark pondersosa pine just below. A draw points the way towards the trail that will take you to the open plateau just beyond the top ridge. Once we reached the top there is a place within the trees that we stand and watch the meadows below where the horses will gather to run, play, and show off for the herd. Its at this place I believe I can sit for hours and feel that only minutes have gone by.

Ruger and I stood there for only a few moments before we both spotted a few wild mustangs walking out of the tree line onto the grassy meadow, then followed by dozens more. What a beautiful site, all sizes and colors of horses moving around the tall grass feeling no danger and knowing that this is their home.

By golly the herd seemed to be in such a peaceful mood, grazing one step at a time, yet still being aware of all thats around them. The head of the herd, a magnificent black stallion would run around the outside of them, then stand for a while in one spot just to look over his family. From where Ruger and I stood I could see my cattle just beyond the aspen grove to the north, they all were there and were doing fine. But this picture, if only everyone could see this. My cattle in the distance in the pasture surrounded by groves of aspen, and then these wild horses just before me in this open grassy

meadow. I just had to stand in my stirrups, throw my arms back and shout out "yee haw, thank you Lord".

I stood there in silence looking down at the herd hoping they didnt hear my excitement. And nothing seemed to have bothered them. While I kept watching I couldnt help thinking about this dream I had several times where I would be riding in a herd of wild horses, I didnt know if I was on Ruger or riding one one of the wild ones. I only know that I was on a horse in the middle of a wild herd and we were all running across a long open meadow with low hanging clouds that almost made it seem like we were riding through the clouds. I was looking all around me and saw so many horses with the wind blowing back their manes and dust rumbling up from their hoofs. I felt as if I were a part of their family with the wind in my face and the sound of a hundred hoofs pounding the earth around me.

You know there isnt too many times that people can say they have lived there dreams and not be fibbing about it, or perhaps just believed that it may have happened that way. Well I have never been able to lie or try to make myself believe something else, cause I know I would have forgotten what I said and then get caught like a fool. So at this point I wanted so badly to make a dream come true and know that it really happened whether anyone else did or not.

Ya know, if you wanted to make a dream come true, all you have to do is have faith in the outcome then get started. I climbed down off of Ruger and took off the saddle then placed it up against a cedar tree, then placed my chaps and hat on top of them. In my mind what I was about to do needed to be a bit more natural than all the gear. Ruger seemed to be a little curious about this, but a little reassurance and a few pats on his neck seemed to be all he needed. I climbed back on top of

my horse with only a blanket and the reigns then started looking over the landscape below speckled with so many horses there was no need to count.

We started walking down the hill towards the wild herd, as slowly and natural as we could. Only a few of the horses would look around and see us, but I guess we didnt seem to be a danger to them, and I also believe that taking the saddle off which took away the sound of leather rubbing helped alot. I couldnt believe we have gotten so far into the herd without spooking them into a run. This was almost like going into a family reunion and not knowing anyone, yet still being accepted.

But of course I might have known it, the black stallion, which you cant pull the wool over his eyes, ran towards us then quickly turned away. This alerted the rest of the herd and so we all started running down the pasture towards the sunset. I couldnt believe it, I was running right in the middle among this herd of wild horses. The sound of the horses yelling, our hoofs pounding into the ground, the dust rising into the air only to meet those low white clouds was exactly the way my dreams had occured, and I did not want this to end.

I believe I could call this the ride of my life. Just looking from side to side seeing these beautiful animals and the powerful feel of my own horse as he ran at their pace was for sure a dream, a dream that is now a reality. As much as I wanted to, I knew this couldnt last all night. So as the tree line and rock formations came into site I rode towards the outer edge of the herd then made my turn back the other way. Once I knew we were clear of the herd I stopped to turn around and watch. They were headed towards a blue and orange sunset with the golden dust rising behind them.

As excited as this made me feel, I also could tell that Ruger

was feeling the same as his eyes watched the herd until they faded into the dust. "Come on ole friend" I said, as I rubbed his neck and turned him towards our lookout spot. Once back where I left the saddle I got geared up again and everything was still feeling like a dream. I stood there beside my horse looking onto the plateau going over and over in my mind every second of that ride.

I knew for a fact that when I got back to the ranch house and anyone asked how my day went, I had to tell them every last detail. And of course I would here things like "Luke, you sure are full of whoppers" or more than likely I would hear "you could have gotten yourself killed you ole fool". But you know, my friends are only concerned, and I thank God for them, my horse, and for giving me my day in the clouds.

CHAPTER 3

Miss Vicky's Pies

No trouble at all

ITS SATURDAY MORNING by golly, and I only have half a days work to do according to my figuring. And this is all the simple stuff, like feeding the calves and horses. Then make sure there is plenty of water, and of course any medicine that some of them may need. But all in all, I should have everything done long before noon. I quess I always looked forward to Saturday afternoons cause it went right along with fishin, bar-b-ques, and maybe going to town.

So once I did all my chores and made sure the animals were tended to, I went back to the cabin and made the morning coffee. I like to set on the porch with my hot cup of coffee overlooking the pasture where my cattle and a few of the horses are grazing next to the pond. Just watching them from up here I can pretty much tell if any of them are feeling bad or not. But this morning they all seemed to be doing just fine and dandy.

I quess setting here looking over the scenery and thinking about my work ending early, I started getting hungry, and I

dont know why, I just had breakfast. But just out of the clear blue sky I kept thinking about this strawberry-rhubarb pies that Miss Vicky down at the merchantile store would bake every now and then for some of the church dinners. I think I started thinking about it so much that I believe I would walk a mile barefoot in a snow storm just to taste one.

Well, there isn't any snow storm or even a flake within miles. But I had to quit thinking about pie for a little bit and go fix some of the corral post that got broken when I was working with my last bronc. And it wasn't him that broke em, it was me. But then he did help some by throwing me into them and then stepped on me just to make sure I stayed. I didn't stay long till I was back on him with my arm flying, yelling and hanging on for all I'm worth. And that's why I need to fix some of the rails also, cause I didn't stay on that much longer.

I do love my horses dearly no matter which ones or how much pain they can give me. But somewhere at one point this ole 150 pound cowboy has got to learn his limitations. I think I read that somewhere, and of course I dont agree with it. I believe that as long as I can walk, talk, ride, shoot, and rope, then I'll just keep doing what I'm doing. The way I see it, God gave me this life with all of its ups and downs, and he can't be wrong. And with that being said, I'll never give it up.

So after pounding the last nails into the corral and wrapping a little extra strapping around the post for good measure I was coming to the end of my chores for the day. And" boy howdy" was I looking forward to this afternoon of taking it easy and maybe even a ride into town. I put all my tools away and stood back to look at the work I just did on the corral. Then all the sudden a great idea came over me. Why don't I go into town to the merchantile store and ask Miss Vicky if she

would bake one of her strawberry-rhubarb pies for me. Oh, this sounded like a great idea.

 I went over to Rugers pen and got him all saddled up and then tied him to the post in front of the cabin while I went inside and got duded up as much as possible. When I go into town I always want to look my best just in case some folks want to talk to me like maybe I am something special, like Miss Vicky does. So with a clean shirt and the dust wiped off my boots, I climbed onto my horse and headed to town.

 Its always been a pleasant ride down into the valley towards towards the town of Greenhorn. And it always seems the last half mile we start to pick up our speed, I quess because we are just anxious to get there. I know that once on the main street there is going to be friends waving and yelling at me, and even strangers tipping there hats looking my way. I don't think you could ask for a better small town than this one. But for this trip my main concern was going to the merchantile store for a special request.

 I hurried down to the end of main street to Miss Vicky's general store and tied up my horse in front to the hitchin post. As I climbed down and started walking towards the door I started getting this crazy, nervous feeling like I always do just before I get to see Miss Vicky, after all, she is probably the purtiest woman these parts have ever seen and she does talk to me like I am somthing special and maybe even a little smart.

 Once inside the store I started looking around as if I were shopping for several items. Then I heard this voice off to my side asking me " Is that you Lucas? Of course I turned around as casual as I could and said " why yes, Miss Vicky, I came in to see if there were any supplies I might need". After saying

this I started feeling like an idiot because when ever I came to town I always had a list and knew exactly what I needed. So how was I going to tell her I wanted to see if she would bake a strawberry-rhubarb pie for me just so I could come back and see her again. It was impossible, so I simply asked her if she still baked those wonderful pies and if she would bake one for me.

Miss Vicky told me she would be more than happy to do so, but all she had left this season was the rhubarb and no strawberries. She said her last pie went to Pastor Daniels when his cousin came to visit. So without thinking I asked if I were to come up with the strawberries would you consider baking me the pies. And without a pause she said she would be more than happy to bake them. I told her I know just the place and would it be OK if I came back in a few days with the strawberries. She told me that would be great and would be happy to bake the pies for me.

I then bid Miss Vicky a good day and went outside to saddle up. I sat atop my horse thinking about everything I just said inside the store and hoping I didnt say anything stupid or out of order. I dont believe I did, so I headed out of town to fulfill my strawberry order for Miss Vicky and the pie.

With my task ahead of me I headed back to the ranch to get a couple of flour bags to put the strawberries in and give the livestock one quick check, cause this may take a little bit longer than I had thought for my days activities. The animals were just fine and I had the sacks in my saddle bags, then took off for Flat Top Mountain. There is one spot on the south side of the mountain that every year about now it always had a good crop of wild strawberries. And by golly I am going to get a couple bags full, take them to town, and then get back to the ranch before nightfall.

MISS VICKY'S PIES

I slowly started riding around the south slope looking for patches with all the little red specks in them. It didn't take long till I saw a whole bunch of them shining in this afternoons sun light. But before I could climb off of my horse to look at them, he started crow hopping around and yelling like something was really wrong. I tried to calm him down and at the same time was looking around for something that might be spooking him. And there is was, no more than 10 feet in front of us, a big ole timber rattler all coiled up and wanting to strike. Now Ruger is used to me shooting off of the saddle so I had no problem getting rid of that snake so we could both calm down.

I am so glad that my horse has a keener sense than I do, or we could have had a real problem. So now on with business. I tied my horse to the nearest bush and walked over to start picking those ripe, red strawberries. And as anyone would do, I would put about 10 or so in the sack then eat another two or so. I could just taste that pie now and started picking a little faster while hummin a few songs I didn't know the words to.

I already had one bag full then started in on the next one. So while I was humming along I thought I was hearing someone screaming. I stood up and listened, then all the sudden Ruger raised up breaking his reigns from the bush and ran up the hill just as scared as can be. I was yelling out to him, but he kept running over the ridge till I couldn't see him anymore. I stood there in silence with a bag of strawberries in one hand and my six shooter in the other. I stood there as quiet as a church mouse waiting for who knows what, then suddenly that same scream echoed into my ears and I knelt down knowing excatly what it was.

There was a mountain lion not far from me, but I couldn't

see him. I was turning and twisting, looking all over the hillside, then finally I spotted him on the rocks above me. He was staring down at me like I was dinner and I stared back like I was on a mission and he was in my way. I felt a little angry cause he scared my horse away, but not enough to shoot him. I fired a round into the tree above him and a small branch fell onto him. This was more than enough to scare him away. So I took a few deep breaths and began picking more strawberries.

What the heck was I thinking, I am on this mountain side several miles from home and town. A snake tried to bite my horse, and a mountain lion scared him away after that. So what do I do, I keep picking strawberries. I quess I wanted that pie awfully bad or maybe wanted to see Miss Vicky again today. What ever it was I just kept picking and I knew that Ruger would head straight back to the corral.

The sun was starting to go down over the Greenhorn which meant night time wans't far behind. I already had one bag full and the other one was getting there . So I stopped and tied up both bags so I could figure out what I needed to do, walk back to the ranch or walk to town then borrow a horse back to the ranch. For some reason I thought walking to town and giving Miss Vicky the strawberries first was a better idea. Darned If I know why, it just seemed better at the time.

So down the mountain I went, at least hoping I could make it to the road before it turned dark. The light started getting dimmer over the mountian line and the shadows became much longer as I walked a little faster down the hill. Finally I could see the outline of the road just ahead of me with what little light I had left. Once I made it to the road I really had to sit down for a few minutes and rest on one of the rocks ahead of me. I sat there a little slumped over taking in every seconds

of rest that I possibly could. But I knew that I better get going cause town was now only one mile away and I think I could still get back home before midnight.

So I jumped up and took no more than two steps forward and tripped over something that ran right out in front of me. I landed flat on my back and then all the sudden this horrible smell was everywhere. "Oh Lord Almighty" I just tripped on a skunk and he decided to spray me with vengeance. All I could do was roll over and over in the road hoping he was gone and so was the smell. He was gone but not the smell.

Now I'm really in a pickle. Skunk smell all over my britches, how in the world am I going into town like this. At least I tossed the strawberries off aways when I tripped, so they should be alright. And I did get only my pants sprayed. But I'm not about to walk into town with no britches. It dawned on me that about a half mile down the road then go up Miners Draw a short piece was a sulfur spring that popped up after all the digging in the area. I'll bet I could make it over there then wash my pants in that ole stinky sulphur water. It will take away the skunk smell, then I'll smell like sulfur, but I'm willing to make that trade.

When I finally got to the spring and started dipping and scrubbing my britches in that smelly water. I couldn't believe I was doing this. I tend to think some fresh cow pies would have been better. So at least the moon was bright and a warm wind just picked up coming down the valley. So I hung everthing over a small scrub oak tree to let them dry off, cause I didn't want some sulfur irritation. I figured I could still spare a little more time at waiting for dry cloths. It didn't take long for that wind to serve my purpose, so I put everything back on and headed back to the road for my final half mile to town.

THE ADVENTURES OF LUCAS CLAY

The wind was still going strong which I was hoping would take care of any lingering smells. I had the two bags of strawberries tied together and hanging around my neck so I knew they were ok. I was starting to walk the final few yards into town and hoping Miss Vicky was still at her store. But just as soon I walked a little passed Doctor Sids office I heard someone yell out "Lucas, hey Lucas". I turned around and it was Doc Sid walking towards me asking if I was alright and if I'm hurt.

This really took me by surprise, so I asked him what he meant and told him I was just fine, even though I didnt look or smell like it. Doc Sid told me he was coming back from the Johnson place and saw my horse standing in the road and I was no where to be seen. He said he took Rugers reigns and tied him to the back of his rig then started calling my name all the way back into town. He was getting ready to call together a search party till he saw me walking down the street. Well doggone it, so I had to him the whole crazy story about my pie craving, the mountain lion, Ruger running off, the skunk, and washing my britches in sulfur. I never seen a country doctor laugh so hard in my life, then once he caught his second breath he said, "Lucas Clay, I swear, God broke the mold after he made you".

So we walked around back of his office so I could get Ruger where he had put him in his pen. And, boy howdy, was I glad to see him. I got mounted up headed out of his gate then Doc said " Oh, buy the way Lucas, you didn't have to tell me about the skunk or sulfur, I could still smell a little of it, just so you'll know as you give Miss Vicky the strawberries". Well now wasn't that just fine and dandy. I told Doc a bunch of thank you's and headed up the street, the whole time thinking just how was I going to handle this.

MISS VICKY'S PIES

I rode up front of the merchantile store but there wasn't a single light on anywhere, and the sign in the window said she was closed. Her house was just a little ways to the edge of town so I started riding that direction hoping it was ok to give her these strawberries at her house. But I still had this one last problem, I did not want to come within smelling distance. So I tied my horse to the post across the street so she wouldn't think someone was in front of her house, then walked over and hung the strawberries to the lantern hook on her porch post. I then went back over to Ruger and rode over to the front of her house. I knew doing it this way I could keep down wind the entire time.

I saw the curtains move back then she came out onto the porch to see who it was. I called out to her "its me Lucas', I brought the strawberries for that pie we talked about". But I had to explain that I hung them on the hook cause I thought she might be asleep. She assured me she was still awake and that it was no problem at all, and then invited me in for a cup of coffee. Of course I had to tell her it was getting late and I needed to get back to the ranch. She understood and hoped that I didn't go to a lot of trouble getting the strawberries. I told her "No Miss Vicky, it was no trouble at all, I just stopped and picked them on my way into town". I told her to have a good night and I would see her in a couple of days.

As I rode away from her house heading towards the ranch, I started thinking about this morning when I was having that craving for strawberry-rhubarb pie. I think the next time I'll just wait for the next church social, cause that would sure be a lot easier. I quess one good thing did come out of this. I get to go back into town and have some of Miss Vicky's pie.

CHAPTER 4

Moon Over Spirit Valley

Feathers of Faith

FOR A MONDAY morning it sure was busy around the ranch. I had three wagons of hay in front of the barn waiting to be put away, and then another two laying in the pasture. There were two of my neighbors, Buck and Sy coming over to help me empty the wagons and then get the last two from the field. If it weren't for these ole cowboys I would be here all day and night picking up hay and throwing it into the barn by myself. But one more man was to be here later in the day, and that was Cody Whitehawk. Cody is my cousin from my mothers side that grew up on the Cherokee reservation near Ft. Gate. We have always kept in touch, and so the last letter he sent said to expect him and his wife to be here sometime today.

It was not only a busy day but also an exciting day. I had more than enough hay for the winter and plenty of company and small talk, which is something I rarely get. Old Buck and Sy were really going after it, throwing those bundles of hay into the barn just laughing and talking the entire time. It was all I could to to keep up with them and still comment on

their converstions. But my goodness, what a blessing that they were here to help. I still had to keep looking at my time piece every now and then cause I would worry about Cody's trip here to the ranch and hoping there would be no trouble. I'm sure the trip would be just fine, but when it comes to my kin folk and friends I seem to worry a little extra.

Just about early afternoon the last wagon was in front of the barn and we were all three throwing the last of the hay inside. My friends laughing and talking had seemed to have slowed down a little bit and so did mine because we were really starting to get soar and tired. But when that last little bundle went into the barn I believe we gained some more energy just long enough to cheer and ha-hoo because the last load was done. As we all sat on the ground leaning against the corral post I started tell telling them about Cody Whitehawk and his wife coming to the ranch today all the way from Ft. Gate. Both of them remembered Cody from a few of the tribal pow-wows we attended several years ago.

Over the years of our friendship both Buck and Sy were always intrigued with my Indian relations and would sometimes joke about my ability for tracking or talking to my horses like they were answering back. Of course I believe it was their way of showing respect and I never saw the need to tell them that the horses actually did talk back to me.

It wasn't that much longer after catching our breath and gabbing for a while we all at once spotted and horse and wagon coming over the hill from town. I just knew it Cody Whitehawk and his wife, cause one dead give away was the painted pony pulling wagon. We all stood up and went over to the lane leading into the ranch to greet the visitors from Oklahoma.

THE ADVENTURES OF LUCAS CLAY

It has been about ten years since I have seen Cody and his wife Helen, so the excitement was mounting up with the pounding inside my chest. The wagon stopped within an few feet of us and we all three smiled from ear to ear as this tall man with long black and grey hair jumped off from the wagon calling out " Lucas Clay, my cousin, how the heck are you?". He also recognized Buck and Sy immediatly and asked how his favorite pow-wow friends were doing. I reached out for Cody's hand and he moved it away and gave me bear hug instead, then Helen jumped down from the wagon and gave me the same. We all stood in that same place talking and patting shoulders for quite a while till Cody said we should start a fire and visit about old times.

Buck and Sy decided they should head back home to do their chores before nightfall. Even though it would be nice to have them stay and visit, I fully understood and thanked them very much for their help today and to be sure and come get me when its time for their hay to put away. After we got Clay and Helen's wagon put away and their horse taken care of, we indeed started a fire out beside the cabin, then I brought out some coffee along with some biscuits. I think we sat there for hours into the night talking about old times and different people in the family and what they were doing.

When I told Cody and Helen that they should stay as long as they like, he replied that their plan was to stay with me for a couple of days then head south towards El Baca to see Helens mother and father before to many years pass. I told him that from here the only way to El Baca was through Spirit Valley and this time of year the mountain run off along with rains the creeks would sometimes flood. Cody told me that they always travel with faith that the great spirit would keep them safe, so how could I argue with that.

The next morning I had the bacon sizzling in the pan, coffee brewing on the stove and a bunch of eggs laying on the table waiting to be fried up. Clay and Helen came out of the quest room with their nose in the air and ready for whatever smelled so good. They had such a long trip I wanted to be as hospitable as I could. As long as they were here I didn't want either one of them to do any cooking or chores. Of course Helen wouldn't go for that at all, and I have seen Clay work harder than any three men combined. That's why I got up a lot earlier just so I could at least do this for them.

My idea didn't last very long when Helen told Clay and I to sit down and tell her how we wanted the eggs. We both obliged her, then sat at the table talking with our cup of coffee. Not long after breakfast Clay jumps up and tells me we should get my horses fed and check on the rest of the livestock. I knew he wouldn't be able to just sit and visit cause it ran in the family. We headed out the door looking right into this mornings bright orange and red sunrise. With the smell of pine and fresh cut hay still in the air, I just knew another blessed day was ahead.

While we were looking for a few calves in the pasture I noticed some clouds over the Greenhorn range were starting to hang lower and covering most of the peaks. I was sure hoping they were going to stay right there and not get any lower, cause when they drop we always have some rain here at the ranch. Normally I don't mind that, but today I was wanting to have a cookout and invite some neigbors over to have them meet my company.

As Clay and I were walking back to the barn he told me it looks like there might be some rain up on the peaks and asked me what I thought about it. Of course my thoughts went to

them leaving in the morning and hoping the trail was open and no washouts. But we both agreed to just wait and see what tomorrow brings. In the meantime we were all going to enjoy the visit and have some folks over for a shindig. Helen had just finished cleaning up after breakfast and was sitting in the rocker reading her daily Bible verses when we came in and told her we were going into town and get a few supplies and to invite some folks over later for a little get together. She nodded her head and said that sounded great.

So Clay and I saddled up and headed to town. We found most everything we needed for the cook out at Miss Vicky's store then made a few other stops to make some invitations out to the ranch. The only one that said they probably couldn't come was Ely Wallace the blacksmith. I always ask him to anything we ever do and he always says he can't. I often wondered if it may have something to do with me shoeing my own horses, or out shooting him at the last three turkey shoots. What ever the reason, he is still invited.

We still kept our eyes on the clouds hanging over the peaks as we rode back to the ranch. Yet still talking about some of the good ole days, like when we tried to out do each other busting broncs to make a living, or which one had a better knack for tracking. I gave it to Clay that he was better at tracking, but he wasn't about to out do me on the broncs.

Once back at the ranch we started to smell somthing so good it almost made our mouths water. There was smoke coming out of the chimney and we knew that Helen was baking something for the cookout. We hitched our horses to the post and went in to see what in the oven. Helen had gone out back and picked some apples then prepared two pies, and more than likely making the whole country side hungry.

So we didn't stay inside very long to avoid getting in her way, so Clay and I went out to get the fire circle ready and get some chairs and tables set up for our guest. Once we had everything set up Clay told me that it looked like I still stuck with some of the Native traditions such as the fire circle and leaving an opening in the circle for the spirit to enter or leave as it wished. And I told him that it isn't just a native tradition, that it was this ole cowboys tradition also. We had most everything ready and a fire going when I saw the first of our guest riding over the hill towards the cabin. It was Buck and Sy coming down like they haven't eatin in weeks. A few minutes later more company were headed towards us in their wagons and few more on horse back.

I believe this get together was going to be one that my cousin Clay and Helen would remember for a long time to come. It was going so well I don't thing anyone wanted to leave, that is until some lightning started displaying its bright bolts just to the west of us.

The storm looked to be quite a ways off and we did have a good nite of roast beef, corn on the cob, and of course some of Helens apple pie mixed with some of the best company and laughing this ranch has heard in a long time. But because some of our company had several miles to go they thought it best to start heading home just in case the clouds got any closer. While everyone was leaving I started putting most of the the things back in the cabin and the shed.

Once they were gone Clay came with me to check on the animals and I told him that maybe they should wait another day before leaving and we will check the creeks first to make sure they hadn't washed out. He told me I just worried to much and it wasn't anymore than a usual spring shower,

besides don't you remember when I told you we always traveled with faith. He then pulled out two feathers from his deer skin pouch which he always carried around his neck. He said "these feathers, my cousin Lucas are my feathers of faith". He explained that when his father gave him these feathers that all of his journeys would be the safest as seen through the eyes of the eagle from where they came.

I knew from all that my mother had taught me about her traditions that this was something that I should not argue with, so I told him that we should go back to the cabin and have a cup of coffee then hit the sack and see what all looks like in the morning.

I was awake long before daylight and had the coffee brewing and the livestock already looked after. As walked back into the cabin, Clay and Helen came out of the quest room heading straight to the coffee pot asking what I thought the weather was bringing. I told them it was nice and clear and looked like another sunny warm day. I did warn them that even though it was clear the rains will take its time getting down the mountain to the low areas , and that a possiblility of some washouts may be possible.

Clay told me that all will be just fine and started getting their supplies ready then went out to the barn to get their horse rigged to the wagon. I went along with him to help with the rigging and make sure they took enough feed and water. I knew everthing would be alright, but even still, I was concerned about any rain mixed with some spring thaw could create some washouts. As I walked away from the barn I looked towards the trail to Spirit Valley and the sky looked as clear as ever.

We had everything all rigged and took the horse and

wagon up by the cabin where Helen started putting some of there belongings into it for the rest of their trip. While we stood there by the cabin, I thanked Clay and Helen for coming to the ranch to see me and staying for a while. And of they told they had a great time and felt a lot better now that got to see me and the ole place again. I told them to be extra careful and to send word when they were home safe.

I stood there in front of the cabin and watched as Clay and Helen headed down the road until they were out of site on their way to El Baca. After he told me about the feathers I had no choice but to believe they would be just fine going through Spirit Valley and on to their destination. So I figured I better get on with my day and went to the barn so I could get my horse saddled up and ride a few fences on my way to town.

When I arrived in town I went to Miss Vicky's merchantile store to make my order and she asked if my company decided to stay another day or so. I told her they had left early this morning headed south to El Baca. She took a deep sigh and said " Oh Lucas, Abe Grayson rode in this morning and told me the creek at Spirit Valley has washed out the bridge and was still flowing awfully strong". She said he came in about an hour ago and I knew it had been around six hours since Clay and Helen had left the ranch. I thanked her then made a quick stop over at the blacksmith shop to have Ely look at my horses shoes.

This took Ely by surprise cause he knew I did that work myself. But I had to explain that I needed a quick adjustment so I could head out across country towards Spirit Valley because of this feeling my cousin and his wife may be in danger do to the flooding. Ely was right on it and then told me to hold

on a minute because he was going with me. I welcomed his help and we rode out of town faster than the dust could rise from the ground.

By the time we arrived at the valley's ridge the sun was going down but we could still see the valley floor both directions and the road which follows the river. We still couldn't see that clear from up here so I told Ely to head up the valley and I would go down, and if we saw any sign of Clays wagon to fire two shots. So we headed down the hill in opposite directions hoping we would not find anyone hurt. It was a clear night tonight so I could see the water running from the bright light of the moon, and it didn't seem to be going that fast. But in a flash flood it doesn't take long for the water to run high then go back to normal.

As I was riding down the road looking towards the water I heard two gunshots from up the valley. I turned my horse the other direction and ran him as fast I could up the valley road towards the shot. I could see the light of a lantern ahead of me but I knew Ely didn't have one with him, and it had to be someone else. Once I got closer I heard Ely yelling along with another man yelling also. I got to Ely and he said "Clay and Helen are up ahead on a section of the road that got washed out from the flash flood. I walked up ahead and sure enough there was Clay and Helen in their wagon with the paint horse still hitched up.

I yelled out to them to make sure they were alright and he told me they stopped along side this large cottonwood tree beside the road to check on the rig and his horses hoofs, when all the sudden they heard this loud thunderous sound of water rushing down the creek heading straight for them.

Clay jumped down from the wagon with his lantern telling me that they were both ok and then went out in front of the wagon to show me the problem. Sure enough the water had rushed around the tree and started washing out the road in front of them. And there wasn't enough room for them to turn around. The water had gone down quite aways, but we needed to figure out how to get them along with the horse and wagon off of this little washout island.

Ely suggested we un-hitch the horse and walk him across the water, then go around behind them and pull the wagon backwards to the good part of the road. Clay and I agreed that, that seemed to be the only way to do it. So Clay took his horse with Helen on top and walked him across the water while Ely and I rode along the roads edge to the back of the wagon. I took my rope and tied it to the wagon while Ely went up front to help quide. My horse and I pulled the wagon along that narrow strip till it was safe on solid road again. We then took it along the edge over to where Clay and Helen were waiting with their horse.

Ely and I both got a big hug from Helen and even one from Clay. While we were hitching his horse back to the wagon I was telling them that this was the craziest thing I ever saw. The water was rushing straight towards them and then it turned just before and went around them. I thought perhaps it was the size of the tree that made the water turn.

After I went on about the water, Clay looked and me and said "it was my feathers Lucas, my feathers of faith". He pulled the feathers from his rawhide pouch and told us that when the eagle sees danger, he knows where it would be safe. And so he told me that the large cottonwood did turn the water, but it

was the great Spirit that had us stop there. He gave me one of his feathers then told me that the great Spirit through the eyes of the eagle would keep me safe throughout the rest of my lifes journeys. I was at a loss for words because this feather was great honor to have.

We decided to make camp with Clay and Helen that night. With the bright moon and a warm campfire we enjoyed another night of each others company. Then just before sunrise Clay and Helen headed out towards El Baca and Ely and I went back to town. I remember one time my father told me to always go with your instincts because chances are God put it there for a reason. And this time I am certainly glad I did. And for that feather in my hat, I believe it's there for a reason also.

CHAPTER 5

Heavens Cowboy

Angels in the Saddle

OH MY GOODNESS what a wonderful day this is going to be. This is the feeling that comes over me as I walk back to the cabin after doing the morning chores down at the barn. It really did seem that my horses and the cattle were feeling the same thing that I was, its going to be a good day. With it being Sunday I need to get an early start on my day so I wouldn't be late to hear pastor Dukes sermon. Duke is not only a very good preacher, but also a good friend. He will ride out to the ranch sometimes especially when he thinks I haven't been to church enough and that I might be drinking and having to much of a good time.

 This is all fine with me, and I do enjoy his company, but when he ask me if I have a fresh deck of cards directly after telling me I needed to cut back on my whiskey and come to more of the bible studies, I can't help but think that this is a man thats no different than me. Regardless, when he gets to preaching at church I will sit there and picture everything he is talking about.

THE ADVENTURES OF LUCAS CLAY

So I better get inside, get cleaned up then put on my Sunday go to meetin cloths. This Sunday I think I will wear that new long coat my sister Lori sent me from back east. The last time I had it on some folks told me I looked very handsome in it. Ok, so those folks was Miss Vicky from the general store, but even still it must do something for me rather than my old one.

Even though I knew it was going to be a good day , I sure wish I had some sort of an idea as to what was going to make it a special day. I know that when that feeling comes over you that the wonder or doubt is not suppose to be there, you just accept it and go with what ever comes about. So for right now I know that all is well and my horse feels the same as we ride into town for church service.

Its only a few miles into town from the Circle S ranch and probably one of the most scenic rides a cowboy could ask for. I have taken it so many times a man couldnt even count that far. I guess that is why my grandpa Elmer decided upon this place to build his cabin and call it home. No matter which direction you go, there is always going to be that perfect picture for your soul. And as I ride my horse into town I cant help but day dream about what it must have been like when my granddad took off on his horse scouting out the territory.

I can see the town of Greenhorn down in the valley with the scent of pine smoke coming out of a few of the fireplaces, and dog or two barking at probably a few of the local alley cats. The sun has already reached the mid morning spot and I'm hoping that I am not the first one at the church. Cause if I am, then pastor Duke is going to hand me a whole bunch of paper to hand out to everyone as they come in. I dont mind that so much, except everyone has to ask "how are you

brother Lucas ?" and that's when I have to start guessing their names.

Sure enough dog gone it, I was there early enough I was given the task of standing at the door and passing out the papers as everyone came in. If I could just remember names better I wouldn't mind it so much. But they all remember me and thats almost spooky. I get to thinking what have I done that they know my name but I don't know theirs. They all smile when they say "good morning Lucas" so what ever they know about me cant be too bad.

Once we all got settled inside and the service began, pastor Duke gave out a hair raising yell "look beyond your eyes, the angels are here". Holy cow, as soon as he yelled everyone started looking up and down the aisle expecting to see an army of angels marching into the church. It sort of took me by surprise also, but then I remember the times when he comes out to the ranch and plays cards, he will do the same thing in order to take my mind off of whatever hand he is holding. But in church I will give him the upper hand, cause thats where he holds the best deck.

Needless to say his entire sermon was about angels and how they play a part in our life. As always, I sat there and could picture everything he was saying, but I sure hope I was doing it with my eyes open instead of closed. I have been chewed out before for having my eyes closed while he was preaching.

When the service was over and everyone was standing around outside talking, pastor Duke came over to me and asked if I had been up late last night or not. And I told him that I had gone to bed early as normal. He said he was just

wondering why my eyes kept closing during the sermon. He then laughed and poked me in the ribs before telling me he would see me on Thursday for cards. I gave him a half curious grin and said "see you then Duke", then walked over to my horse.

Just before I got my foot raised to the stirrup, Miss Vicky came over and asked if I would come by the store tomorrow and help her sort out the order that I had given her last week for supplies and the other order that Mr Appleton had given her the same week. Of course I told her that would be no problem at all and I would be there first thing in the morning. I don't know Mr Appleton very well and I guess it didn't matter, I just didn't want to turn down an invite to help her. So I saddled up and headed out of town towards home.

There is a place half way between town and the ranch that has a view that you can see for miles, and when I am not in a hurry I will stop and sit for a while just so I can see the ranch and the whole country side surrounding it. So today with nothing pressing me I stopped and starting looking over the country side, for no other reason than to take in the view and remembering everything Dukes sermon was about.

I believe I can sit in the saddle for hours just looking over the countryside and imagining what everything would have been like many years ago. I dont know if its my imagination ,a deer or there really is a rider down by the Greenhorn creek running his horse towards my ranch. After all we are looking at several miles of wide open spaces and I can only see so far. And then a rider anywhere in these parts is not uncommon.

I grabbed the binoculars out of my saddlebags hoping to get a better look as to who the rider was, but every time I tried to focus in on him there would either be a tree or boulder in

the way. I headed on down the road towards home and the entire time hoping I could get a look as to who was riding along the creek towards my place. I stopped my horse at an open area of the road so to have a clear view of the valley below, then grabbed my eye glasses again for a better look. All I had to do was wait for this mysterious rider to appear within my site.

As I sat there waiting for this mystery rider to appear I was looking around the valley and the mountains just day dreaming about this mornings angel sermon and the pot luck dinner we had afterwards. And wouldn't you know it, I got to looking around too much and must have missed the rider when he came into the clearing. So if he was headed to my place then I better start heading to the house cause its probably someone coming to see me.

I rode into the barn yard at the ranch looking around the area and didnt see anything out of the ordinary. Even rode up to the windmill at the top part of the pasture and still didnt see anything. I figured at some point I need to decide if it were just my bad eye sight or someone riding on past. Either way I needed to get busy doing my chores or there might be a bunch of rowdy livestock. So I rode back down to the barn to unsaddle Ruger and start in on my work.

Ya know I really look forward to doing the chores, cause unlike some other folks I love doing what I do here at the ranch. It gives me a sence of freedom and fullfillment taking care of what God has provided for me. And if an adventure or an obsticle sometimes would arise, then even the better, I am all for it. And today my mind is on feeding my livestock and who in the heck was that rider down in the valley heading towards my ranch.

THE ADVENTURES OF LUCAS CLAY

I guess I shouldnt dwell so much on that rider cause it really could have been some traveling cowboy or one of the neigbhors looking for one of his calves that ran off. But while I was throwing hay down to the feeder from the loft I saw a man on horseback standing at the gate above the pasture. I waived my hat at him and he waived his hat back. I climbed down out of the loft I started walking towards the gate, but then when I looked up I didnt see man or horse anywhere in site.

If there ever was a time to get goose bumps up and down your spine, this might be the time. My eyes were going back and forth from the far west to east then north to south. Where in the heck did that rider go. I know for sure I stood there in the hay loft waiving my hat at this man, and he even waived back. I don't think I have been having any ill feelings, other than a little stomach uspset after some of that desert after church, but I don't believe that had anything to do with this.

I walked on up the pasture to the gate where this rider was standing so I could take a good look at the horse shoe prints. Sometimes you can tell if it was a local blacksmith or not by the way the shoes edges were formed. I got to the gate and opened it to see the ground on the other side and I was simply shocked out of my boots. I did not see a single print anywhere. Here at the gate is all dirt from all the activity in and out. So if there were any fresh prints it would shine out like the sun. All I needed to do at this point was lean up against the gate post and take a few moments of relaxation, or something close.

Now I knew that it only took me no longer than four minutes to climb out of the loft and onto the ground. Then walking towards this gate wasn't any longer than a total of five. I at

least would have seen the rider as he rode away somewhere in these meadows within that time. I think right now I am going to go back to the cabin and put on a fresh pot of coffee then sit on my porch for the rest of the day. Somewhere during this relaxation I think all this can be figured out.

So I am sitting here in my rocker on the porch with my feet hanging over the rail and sipping on my fresh cup of coffee. Just looking around at the ranch and taking in the fresh smell of the pine trees and the sounds of the ranch. I dont think a man could ever ask for a better Sunday afternoon than this. But then there is this little puzzleling mystery about the ghost rider standing at my gate. But sometimes these things happen out here, whether its my imagination or just plum tired.

In any case Sunday is meant for rest and at least I will take the second half of it for that reason. So my eyes started to shut then open back up again, then I just gave in and let them shut for as long as I could. Which dog gone it wasn't very long, cause I kept hearing this voice in the distance yelling like a wild man. When I opened my eyes I was hearing that same yelling, so I jumped up from the rocker and listened closer. I walked out in front of the cabin and saw a rider coming down the lane with a cloud of dust behind him.

I couldn't quite make out who it was at first but as he got closer and a little louder I could see that it was pastor Duke. I walked further out to meet him and when he got near to me I didn't think he was going to stop. I jumped over to the side while he came to a dust bubbling halt. What in the heck is wrong with you? I asked him. And all he said was that he wanted to make sure I was doing ok cause he had heard back in town that some cattle rustlers were on the move in the territory and he knew I had a fairly large herd.

THE ADVENTURES OF LUCAS CLAY

Well ole Duke got down from his horse and asked me if everthing was alright. I told him I had heard about the rustlers and that they were working near Capron about 50 miles west of here, so what in the world is wrong with you, you never act this crazy before if something is wrong. Well he looked me straight in the eyes and said " Lucas Clay, I have been having this dream that you might be in some sort of danger and I keep seeing this tall man riding a palomino every time I have these visions about it.

Now this comment really did make me stop dead in my tracks, because for sure the man at the gate earlier was sitting on a tall palomino horse. I told pastor Duke to tell me everything he has seen or even thought he saw as far as this mystery man on a palomino and what he has to do with me. He said he didn't know that much, just that everytime he had this thought it had something to do with some cattle rustlers and this mystery man at the same time.

You know I always thought of myself as man of common sense and an answer to everything as long it wasn't to complicated. But right now I am beginning to think that this is more of a spiritual sign than any intuition. I asked Duke to come up on the porch and have some coffee with me while we sorted this thing out.

Well, Duke and I got settled into the rockers on the porch, but I figured it was just to late in the day for another cup of coffee, so this little sipping glass of whiskey will surely hit the spot. We kinda sit there for the longest time in silence, probably wondering how to start off this conversation about todays events and as to why Duke came out to the ranch in the first place. So I went ahead and started this off by telling him that I have always been a faithful and God fearing man,

and that my instincts have to be more spiritual than just a gut feeling. Then I told him about seeing this strange rider while riding home, and the horseman on the Palomino at the gate.

He sat there shaking and nodding his head like he was really ingulfed in what I was saying. So I stopped and let him tell his story about these visions he said was going on in his head. Duke didn't really know what it all meant, just that he kept thinking about these rustlers at my ranch and then would see a tall man on a palomino horse standing in the distance. He was very hesitant about telling me the part when I confront the rustlers, but I finally got it out of him after all of the beating around the bush he was doing. And his answer sounded vague at the least.

Its not that often, in fact never, that two grown men would sit and talk about visions they have been having and what they think it might mean. But then Duke and I grew up together and have seen everything life has to offer in these parts, and frankly I quess we have just told each other what ever the heck we were feeling.

I think we sat there talking on the porch for most of the afternoon and not realizing it because over half of the sipping whiskey was gone. I don't think it really mattered though because we got in some good visiting time along with solving the worlds problems. We just didn't have an answer for the current mystery problem. But that didn't mean we haven't come up with all types of different answers for everything else.

Its getting later in the day and I am going to need to start my chores of feeding and watering the livestock then bringing in some wood for the stove. So as Duke was sitting there nodding his head up and down I figured I had better tell him that we need to call it a day so the chores can get done and he

can ride back home safely before dark. He didn't seem to be hearing what I was saying, so I told him "Duke, why don't you just stay here tonight then head into town in the morning". He nodded his head as if saying "OK" so I went with that and showed him where he will be bunking down for the night.

 I got my ole friend settled in for the night, then before it got to dark I went down to the barn to get started on the hay. Once I had the hay bin filled I went back down and made sure the water was up on the tank. Standing there looking around while waiting on the water to fill, I could have sworn I saw a horse and rider standing in the pasture near the gate. Surley I thought this has to be my imagination or just dancing shadows this time of evening. But then when I heard the horse yell while standing on his back legs, then take off towards the sunset, I knew this was real.

 I really didn't know what I should do at this point, either saddle up and take off after the rider or just finish my chores and get into the cabin. I knew dog gone good and well if I went into the cabin for the night I would never get any sleep for laying there thinking of this rider and why he is showing up at my pasture gate all the time. I believe I can pretty much say that he is not a neighbor or even from around these parts. So I figured I can still see with what daylight there is left, so I saddled up Ruger as fast as I can and headed up to the pasture gate.

 I opened up the gate and latched it behind me once on the other side, then looked up towards the hills and saw the rider headed towards the tree line on the other side. So I gave my horse a heel in the side and we went at a full run toward the trees, trying to keep my eyes on him the whole time. Now Ruger and I used to win several races at the local fair, so I

knew we would catch up to this man in no time at all. We got so close that I started yelling out to him to stop but all he would do was look around at me while he kept on running.

He was in full sight the entire time till he rode over this rocky ridge and I couldn't see him for no more than a few seconds. But when I got to the top of the ridge he was gone. I stood there looking all around with such disbelief that he was nowhere in sight. I started riding down the ridge for no than a few feet then I heard someone yell out my name. I looked towards the sunset and saw the silhouette of a rider sitting tall in his saddle.

I sat there looking up at this dark figure and had a whole line of goose bumps going up and down my spine. I wanted to answer back but this moment of mystery had finally caught up to me and my speech was frozen. This rider was about 100 yards away from me with the light of the fading sun behind him, yet he said my name again and it felt like he was sitting directly beside me. I called out and asked who he was and why he was here on my ranch. He simply said in a commanding yet soft voice, " They will be coming soon Lucas, protect what is ours".

At a blink of an eye he had dissapeared into the sunset with nothing else said and no dust to show his exit. I couldnt understand exactly what he was warning me about nor what he meant by "protect what is ours". It was almost like he was saying he had a stake in my ranch, but I am the only one left from the Clay family. I sat there until the sun was giving out only a sample of light, thinking about all possibilities, but came up with nothing. From up here I noticed a lantern light had come on down at the cabin so I headed back down in hopes I could get some reasonable answer from pastor Duke.

THE ADVENTURES OF LUCAS CLAY

As I am riding down the pasture towards the cabin I am trying to think how to explain tonights events on the hill to Duke, and in such a way that it doesn't sound like I had to much of that sipping whiskey myself. With these visions he told me he was having I am thinking that anything I have to tell him about tonight just might ring a bell in his mind and come up with something.

I walked into the cabin and pastor Duke was sitting in a rocker next to the old stove wrapped in a blanket, then asked me, " Luke, did you bout get yourself lost out there, I was fixin to come look for you". I didnt have any choice but to start telling him about the rider and everything he had said and done.

Duke told me that when God had something to tell us he would sometimes show several unexplained events in hopes that we would add them all up and see the answer. Holy Cow, was this a complicated reply or what. Now I believe that God is true and that all life comes through him, but the answer that Duke gave me was far from what I needed to hear. In my mind there is a horseman riding on my ranch calling out to me about the property that he thinks we both own.

I told him that we both need to get some sleep because it was getting way too late and sunrise will be here quicker than we think. I dont know about Duke, but I had laid there for more than an hour thinking about everything that had gone on today and everything thing that I might have done to make it different. Yet I also know that when I wake in the morning everything will have a more reasonable prospective and I will find out that this was just me adding more to something than what is really there.

Well the next morning I was up as usual long before any man or beast. Had a pot of coffe brewing on the stove and

headed out the door to do some morning feeding. I got half way across the barnyard and everything seemed so quiet, so still and calm. I didnt hear a single noise from the pasture, normally some of the cattle would be yelling cause they saw me coming out the cabin door. The morning light was barely showing over the eastern ridge which still gave me enough to see any figures in the pasture. I didnt see a single head anywhere, not by the water tank and not even grazing.

My horses were still in the corral, and they were going back and forth in their runs like every morning when I come out. I could see that the gate to the pasture was still closed, but where the heck are my cows. I went up to the hay loft hoping I could see a little better and I saw the entire pasture or should I say an empty pasture. I knocked some hay down to the horses and went as fast as possible back to the cabin to wake Duke. He was already up and was starting to pour his coffee. I was out of breath and told him to get ready to go, because the cattle are gone.

I just knew it had something to do with that mystery rider. Here he comes along and then all the sudden my cattle come up missing. Duke told me to just calm down that perhaps they are all on the other side and you just cant see them. I told him they are at the barn pasture every morning waiting for me to spread some feed. What ever the case may be, I am going down and saddle up two horses so we can go out and find the herd. I brought Dukes horse up to the cabin and we both rode out into the pasture searching for them.

Duke rode towards the southwest and I took off northwest. I would ride a little ways then stop to look around and still nothing was to be seen. I looked off into the distance and could still see Duke riding around, so it didnt seem he

was seeing anything either. I decided I better ride over the pine ridge and check the fencing just in case they knocked it down. I got to the fence and it was laying down and coiled up against the rocks. I climbed down to check and saw that it wasnt knocked down and that all rows had been cut.

I rode back over so I could have a clear view of Duke then started waving my hat in the air and riding in a circle. He spotted me right off the bat and came running my direction. I showed him the opening in the fence and where it had been cut and not just ran over. He then reminded me of the news in town about some rustlers that had been working in the area, and he bet anything that they were the ones who have my cattle. Well following the tracks over the open country was not going to be a problem, so we took off with our eyes wide open in all directions.

We followed cattle tracks all the way to the top of Bishops Divide and then down the draw to Ophir Creek. We stopped in silence for the longest time and then in the distance we could hear some cattle yelling. We looked at each other and headed towards the sounds knowing that there were no other ranchers grazing in this area. We kept close to the tree line as we rode so that we would blend in and not be out in the open. When we came to a turn in the valley we saw close to 80 head of cattle and perhaps a half dozen riders with them.

We knew that just riding down into the area with guns blazing wasnt going to work very well. So we thought if we could just get ahead of them and ride out into to open the rustlers would stop the herd and then come see who we were. At that point we honestly believed we could get the drop on all six of them. This may be wishful thinking but we didnt have to many choices. After all we are looking at a half dozen

rustlers moving with 80 head of cattle and only the two of us to stop them.

We followed up on this plan and worked our way a good 500 yards ahead of the herd then started to ride down into the draw so we could be seen. No sooner than we made it all the way down we noticed about twelve riders coming down the other side and splitting up in order flank the herd. Duke and I stood there in the pathway of the herd getting ready for whats to come. We had our rifles drawn down on the rustlers as they came our way and then a few shots rang out from the other twelve riders.

The rustlers seemed to have abandoned there dirty deeds and ran directly towards us. When they saw the two of us drawing down on them they all stopped and threw their hands into the air. By golly this is going a lot better than I thought and Duke took a big sigh and told me "you damn right Luke", that was a little unexpected coming from a preacher. In any case we sat there on our horses with six rustlers on the ground and twelve other riders coming our way. As they got closer I could see Marshall Grayson and a bunch of other townsmen from Greenhorn.

Duke recognized this group of men also and said to me exactly what I was thinking, "how in the heck did they know we were here"? I didnt have an anwer for that, but was awfully glad to see them. Marshall Grayson came riding over to us while the other men started gathering the rustlers guns and tying them up. He asked if we were ok and that they had tried to get here sooner. But all I could do was sit there in shock and ask him "how in the heck did you know"?

He told me a man came riding into town early this morning and yelled out to me and my deputy at the office that you

and pastor Duke were in trouble with a bunch of rustlers. He even told us where you would be. He said the man rode off just as fast as he came into town. I asked him if this man sat real tall in the saddle and rode what looked like a palamino stallion. He told me he believed that was exactly the man and horse. I couldnt believe what I was hearing, this sounded just like the mystery rider I saw as I was coming out of town and then the rider standing at my pasture gate.

As my mind was trying to make sense of this I still needed to concentrate on the business at hand. So with all the extra help we turned my herd around and headed back home towards the Circle S ranch. With the early morning sun looking us in the eyes and the sounds of my cattle in front of us, my thoughts was still on this man who seemed to have saved my cattle and perhaps mine and Dukes lives.

We had about ten more miles to go before making it back to the ranch, but I could have sworn the entire time that every now and then I would look upwards towards the ridges and see a rider following us the whole time. I wasnt about to say anything cause so far all was going just fine. We finally made it back to the ranch and had all my cattle back in the pasture and the fences repaired. I couldnt thank the marshall and all the other men enough before they left. Duke hang aroung long enough to make sure everything else was going to be ok, then went back home himself.

I went inside to get something to drink when I noticed something sticking out from my book shelve that hadnt been there before. It was an old picture of my grandpa Elmer. I stood there for the longest time in amazement gazing down at the picture, not knowing whether to laugh or cry. It was a photo of him on his palamino stallion sitting as tall as any

cowboy could. I took my drink and the picture out to the porch to just sit and let my thought take it all in.

With my eyes a little on the glazy side I looked off towards the pine ridge and saw a rider standing tall in the saddle, waving his hat in the air. I jumped up and ran out into the barnyard waving my hat back at him. In my heart I knew that heaven had sent me an angel in the saddle.

www.ingramcontent.com/pod-product-compliance
Lightning Source LLC
Chambersburg PA
CBHW021042180526
45163CB00005B/2244